Swapnaa Tamhane
Mobile Palace

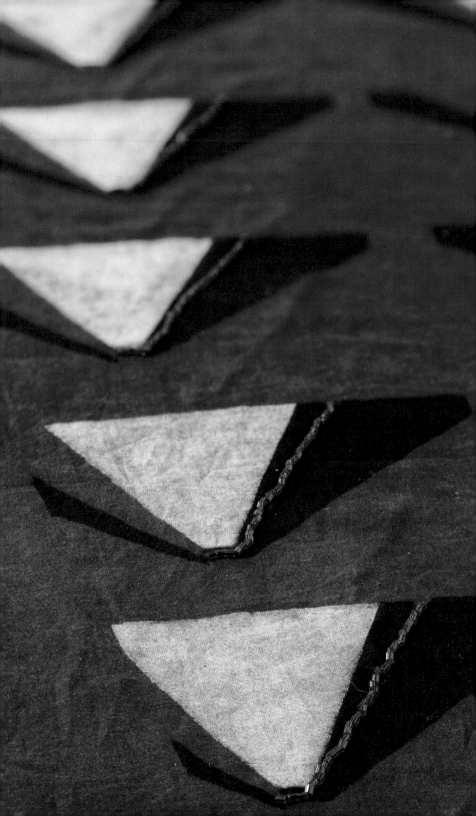

Swapnaa Tamhane

Mobile Palace

Resist.

Print.

Repeat.

Edited by **Deepali Dewan**

Contents

page i: Detail of Swapnaa Tamhane,
Wallpaper, 2017, water-soluble graphite
on handmade khadi paper. 60 × 45 cm

pages ii, iv, viii–1: Detail and installation
views of *Mobile Palace*, 2019–2021,
natural dyes, appliqué, and beading
on cotton. 115 × 700 cm (each panel),
3.5 × 14.25 × 12.5 m (installation)
Swapnaa Tamhane, with Salemamad
Khatri, and Mukesh, Pragnesh, and
Avdhesh Prajapati, and Bhavesh
Rajnikant. Assistance from Sine Kundargi-
Girard and Lydia Haywood-Munn.

page 2: Views of Ajrakhpur, Gujarat,
India, 2022.

page 3: Views of a cotton gin, Kutch,
Gujarat, India, 2022.

Foreword

THE COVID-19 PANDEMIC has forced us to reconsider how we engage with each other. The many reasons to gather—from family dinners to political protests—have had to be reconfigured and reinvented during this time. The ROM-original exhibition *Swapnaa Tamhane: Mobile Palace* allows us to pause and reflect on what gathering, collaborating, and being together mean today. The textile installations created by artist Swapnaa Tamhane and her collaborators Salemamad Khatri, Mukesh Prajapati, and Qasab Kutch Craftswomen Producer Co. Ltd. encourage us to experience different kinds of immersive spaces marked by vibrant pattern. These installations draw from India's rich history of cotton as a tool of anti-colonial resistance to make spaces for imagining new futures together.

In this publication, four essays approach Tamhane's art from different perspectives, and the accompanying images take us on a visual journey from the landscape of Kutch in Gujarat, India, to the artist's studio in Montreal, Canada. Tamhane's rich body of work is on display together for the first time in this exhibition. She was the 2019 recipient of ROM's biennial IARTS Textiles of India Fund, which supported the production of *Mobile Palace*, the artwork at the centre of the exhibition. The grant was established in honour of the late Arti Chandaria to celebrate the splendour and influence of Indian textile arts.

I am grateful to long-time ROM patron and arts advocate Pulin Chandaria and the dedicated volunteers and supporters associated with ROM's Friends of South Asia for generously supporting this publication.

Josh Basseches
ROM Director and CEO

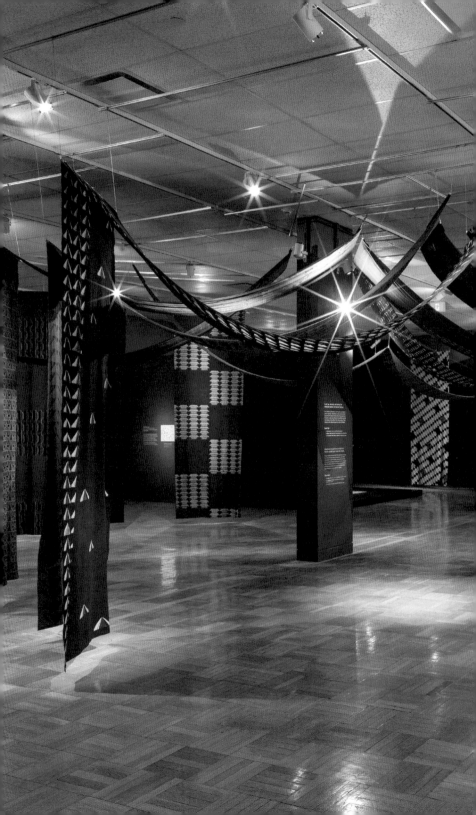

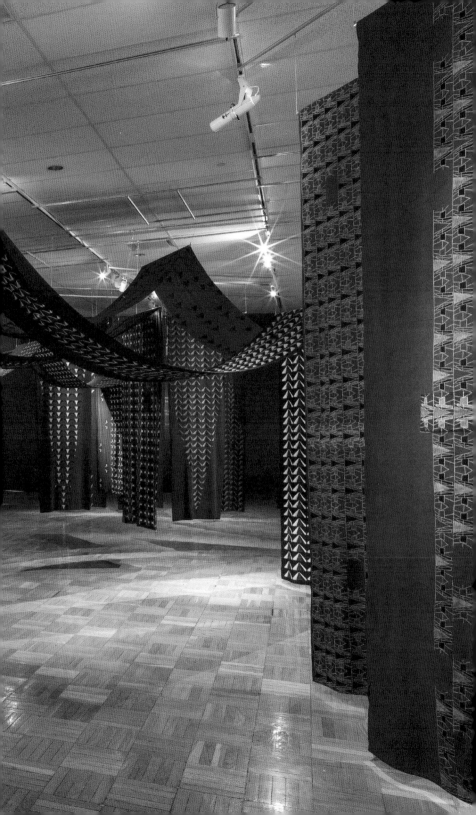

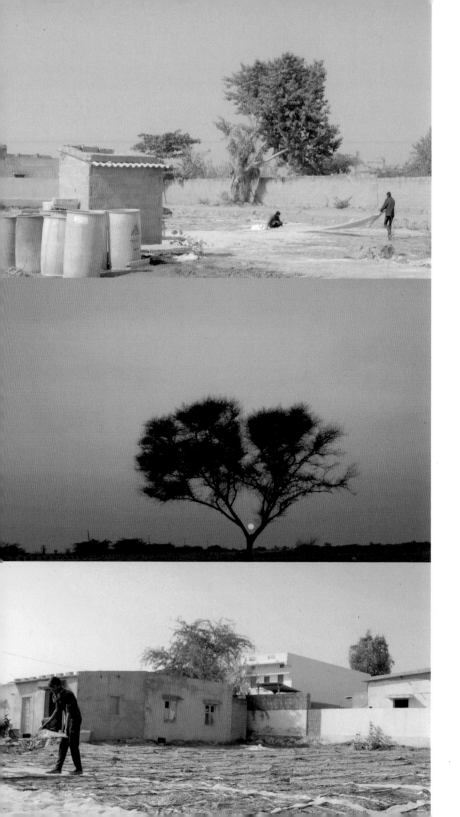

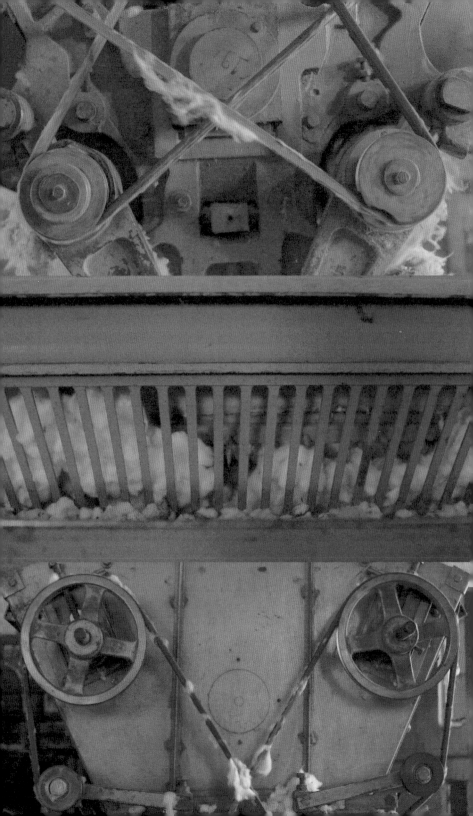

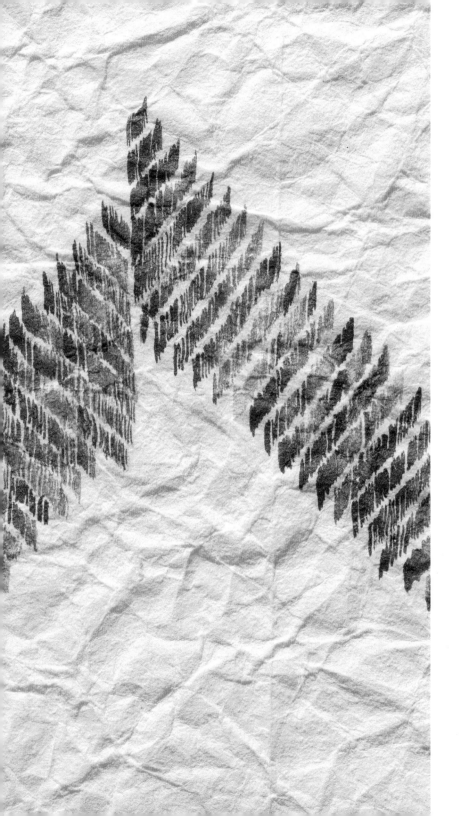

Making a Mark /Deepali Dewan

A line on paper. Then another next to it. Both drawn by hand. They resemble each other, but they are not the same. Each is unique. They don't perfectly line up. The paper underneath is uneven, holding the imperfections of hand-spun cotton cloth (*khadi*) turned into pulp, dried, folded, and crumpled. Textile transformed into paper. Then more lines, resembling the embroidery on *phulkari* textiles. The imperfections are deliberate: an index of the artist's hand and a practice common within embroidery communities to protect against the "evil eye" (*nazar*). Paper transformed into textile. Ink on paper and thread on fabric: both are about making a mark.

This drawing, *Translation*, 2017, is one of the works in the exhibition *Swapnaa Tamhane: Mobile Palace*, which features textile-based installations and works on paper reflecting the artist's larger body of work exploring what it means to make a mark. The works harness different moments in India's history to push back on colonial ideas about the hierarchical separation of art and craft, architecture and textile, permanence and impermanence, rigidity and fluidity. Together, the works create an aspirational space, one that changes our relationship to our environment.

Tent: A Space for the Ceremony of Close Readings, 2018, is a drawing in and on fabric: cotton panels are used to make a tent-like space, and printed patterns cover the outside and inside of the structure. A lantern illuminates the inside, creating patterns on top of patterns. The space is warm, soft, enclosed, feminine, in contrast to the cold, hard, open, masculine modernist architecture that the patterns are based on. It is not ornamentation that supports architecture but architecture that supports the experience of pattern. That is the opportunity for close reading that is being offered: to study and reflect on the hands that were involved in making each element—from the spinning of yarn and weaving of cotton fabric to the carving of the wood blocks, printing of the pattern, and dyeing of the fabric. An audio of the artist's voice reading passages from K.G. Subramanyan's 1986 essay "Do Hands

Detail from Swapnaa Tamhane, *Translation*, 2017, water-soluble graphite on khadi paper. 44.5 × 58.5 cm

Have a Chance?" advocates for local makers and the centrality of the handmade in India's modern economy.

There is a gathering of many hands in the exhibition. Tamhane conceptualized each piece, came up with the overall design, and applied embroidery and appliqué. She collaborated with artists from the region of Kutch in western India, long known for printed and painted cottons exported around the world. Mukesh Prajapati, his sons Pragnesh and Avdhesh, and nephew Bhavesh Rajnikant carved the wooden printing blocks, discerning how to translate Tamhane's designs into functional three-dimensional form. Salemamad Khatri used the blocks for printing the fabric panels according to Tamhane's arrangements and at his own discretion. The embroidered circular mirrorwork glinting on some of the cotton panels created by the women from Qasab Kutch Craftswomen Producer Co. Ltd., and followed Tamhane's colour and placement choices and the women's own technique. Beyond these main contributors, there are other hands: those who picked the cotton, those who worked the machines in the cotton mills, those who made the dyes from vegetable and mineral sources used in the printing, those who assisted with the beading.

All the works in the exhibition draw on India's long history of cotton—as a luxury fabric desired by the world and as a political tool of anti-colonial resistance. Beginning in the 18th century, European imperial powers took control over the trade and manufacture of India's cotton, moving production to industrial textile mills abroad. British colonization created an environment in which people in India were coerced to buy cheaper, lesser-quality, foreign-made cotton products. In early-twentieth-century India, the anti-colonial Swadeshi movement mobilized around spinning and wearing cottons from India. Indian-owned textile mills paved the way towards self-reliance and self-governance.

Mobile Palace, 2019–2021, is a large, deconstructed tent consisting of eight-meter-long fabric panels of machine-made cotton cloth. Printed patterns cover the surface in different motif, colour, and pattern combinations. Each panel is unique. But rather than appearing like a decorative enclosure where the eye seamlessly glides over the surface, the patterns are interrupted. The interruptions manifest as breaks in the pattern, incomplete motifs, appliqué that introduces a new colour

creating combinations impossible through dyeing alone, and beading that aligns with the pattern but glimmers in the light. The choice of machine-made fabric is deliberate: instead of using the political symbol of hand-spun cotton (khadi), Tamhane chose to use cloth from Indian industrial looms, the kind that struck at the heart of the imperial economy by supporting domestic rather than foreign production. The interruptions are visual and conceptual—breaks in the pattern represent breaks in old ways of doing things, making space for something new.

The textile installations in the exhibition draw from a history of design in India. On the one hand, they draw from eighteenth-century tent complexes from the South Asian and Islamic world, which created spaces transformed through fabric, colour, and light. Often referred to as "mobile palaces," they were used by royalty for leisure activities, diplomatic meetings, and military missions and allowed for an ease of movement around the kingdom.

On the other hand, the motifs on the textile installations are drawn from India's modernist architecture and are seen today as symbols of self-governance, progress, and modernity. In the decade after the end of British colonialism, India invested in building for a new nation using the latest principles of modernist design, which emphasized function, simplicity, and rationality through geometric forms, strong horizontal and vertical lines, and reinforced concrete. Tamhane was especially drawn to the Ahmedabad Textile Mill Owners' Association building (ATMA House), designed by Swiss-French architect Le Corbusier and completed in 1954.

In *Mobile Palace*, the printed motifs are adapted from the entry ramp, columns on the facade (*brise-soleil* or "sun breakers"), and niches in the curvilinear walls of the auditorium where a community of textile mill owners would gather. In this way, the motifs move from the outside to the interior of the building. And yet Tamhane pushes back on these architectural histories and their elite, male-centred legacies. The spaces of her textile installations are inclusive, malleable, ephemeral, feminine, nomadic. They are a soft architecture more in tune with the contemporary moment, where the legacy of royal tents can be claimed today by everything from the wedding tent to the roadside tea stall to the tent encampments associated with protest sites around the world.

Achadiya 1, 2020–2021, features the drop cloth that was used to absorb excess materials during the printing of the panels in *Mobile Palace*. Tamhane had it dyed in indigo to reveal the layers of patterning from the many textiles printed on top of it. It is a cloth that was never meant to be seen, where the image emerges from deep within its weave, to which Tamhane has then applied and embroidered mirrors. Each mirror is like a portal or window. The artwork's display on aluminum rods and steel pipes gestures to an industrial loom like the ones used in India's textile mills.

India was a major early centre for the production of indigo, which was desired around the world for its rich hue and naturally colourfast properties. It was also one of the products in the insatiable colonial economy that used enslaved and forced labour, from South Asia to the Caribbean, for its cultivation, leading to anti-imperial revolt. These histories and tensions are carried in and evoked by the blueness of the cloth, pointing to the potential of cloth as resistance.

Let's return to the drawing we started with. Phulkari textiles come from the region of Punjab in the northwestern part of the subcontinent. There is a province of Punjab on the India side and on the Pakistan side, a casualty of Partition in 1947, when independence from colonial rule coincided with the severing of the region into two countries along communal lines, sparking one of the largest forced migrations in human history. Phulkari textiles, made by the hands of mostly Sikh mothers and grandmothers, are an embodiment of female networks and familial bonds that resist the making of political borders. Their threads are stronger than the shifting boundaries of nations. Making a mark is an act of resistance. The impression of a wood block onto a textile surface, the clinging of dye to mordant, thread piercing through fabric, line drawn on paper. All these are marks that disrupt one sense of order and make a claim for a different one. In this way, pattern has never been simply about decoration. It is about how making a mark can shape new ways of seeing, thinking, and being in the world.

* Some of the wording in this essay was adapted from the exhibition label text, co-written with Kendra Campbell. Much of the content was developed through extended conversations with Swapnaa Tamhane during October–December 2021. I am grateful to Swapnaa for her generosity, creativity, energy, and intellect. Thanks also to my ROM colleagues for their support during this project, especially Dr. Sarah Fee, ROM Senior Curator of Global Fashion & Textiles (Asia & Africa), whose exhibition *Cloth that Changed the World: India's Painted and Printed Cotton* served as inspiration and precursor for this one.

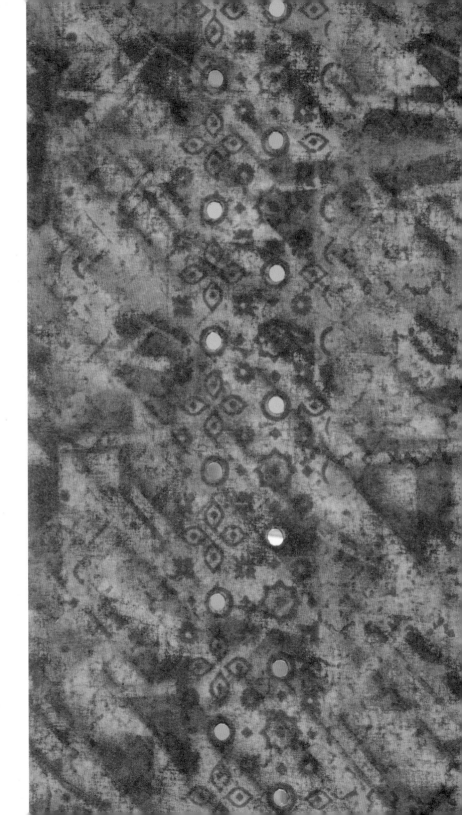

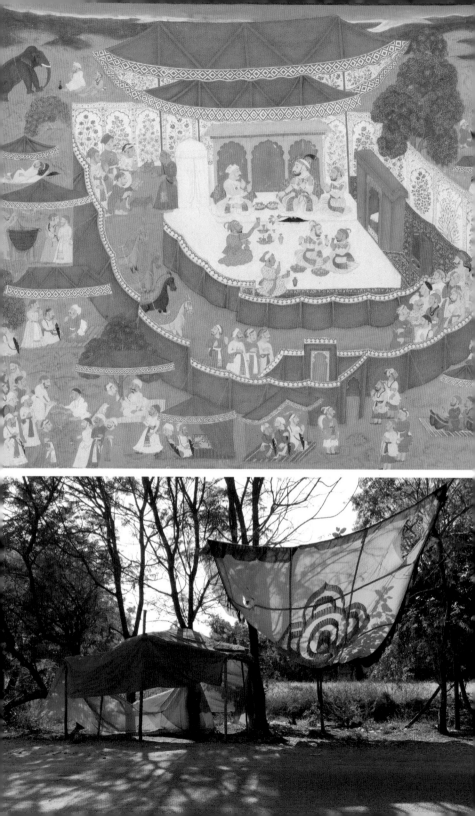

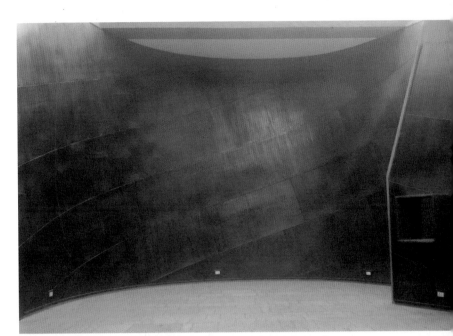

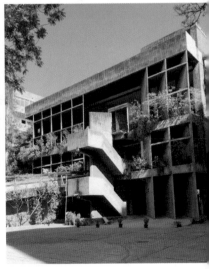

Views of Ahmedabad Textile Mill Owners' Association building (ATMA House): auditorium, exterior facade, interior staircase. Designed by Le Corbusier, with site architect Balkrishna Doshi, completed in 1954, Ahmedabad, Gujarat, India.

opposite above: Attributed to Jai Ram, Maharana Sangram Singh II receiving Maharaja Sawai Jai Singh of Jaipur feasting in camp, around 1732, watercolour on paper, Udaipur, Rajasthan, India. Courtesy National Gallery of Victoria, Melbourne AS100–1980.

opposite below: View of roadside tents, 2020, Baroda, Gujarat, India.

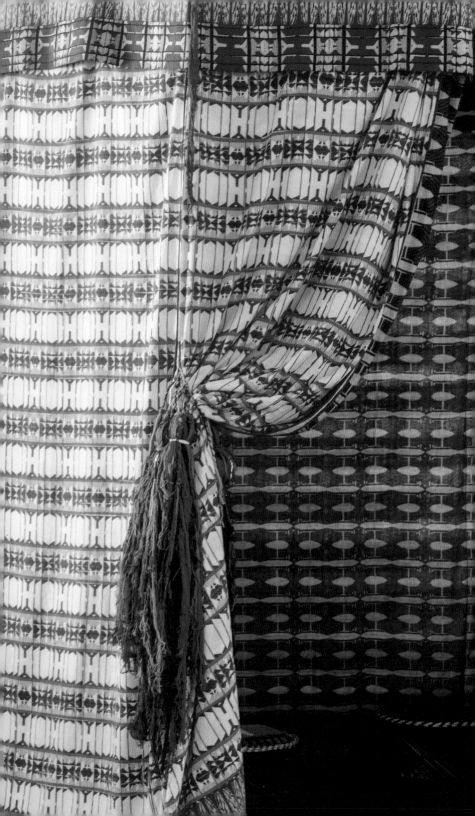

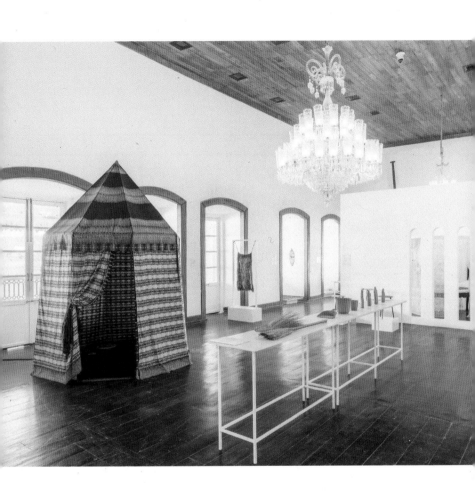

Detail and installation view of Swapnaa
Tamhane, with Salemamad Khatri and
Mukesh Prajapati, *Tent: A Space for the
Ceremony of Close Readings*, 2018,
natural dyes on cotton, cotton tassels.
284 × 223.5 cm. This work was
commissioned by Serendipity Arts
Foundation and was first shown as part
of *Matters of Hand: Craft, Design and
Technique*, curated by Rashmi Varma at
Serendipity Arts Festival 2018, Goa, India.

page 12: Wood carving tools, wooden
blocks, 2020, Pethapur, Gujarat, India.

page 13: Mukesh, Avdhesh, and Pragnesh
Prajapati, and Bhavesh Rajnikant.
Printing blocks for *Tent: A Space for the
Ceremony of Close Readings*, 2018, and
Mobile Palace, 2019–2021, teak wood,
Pethapur, Gujarat, India.

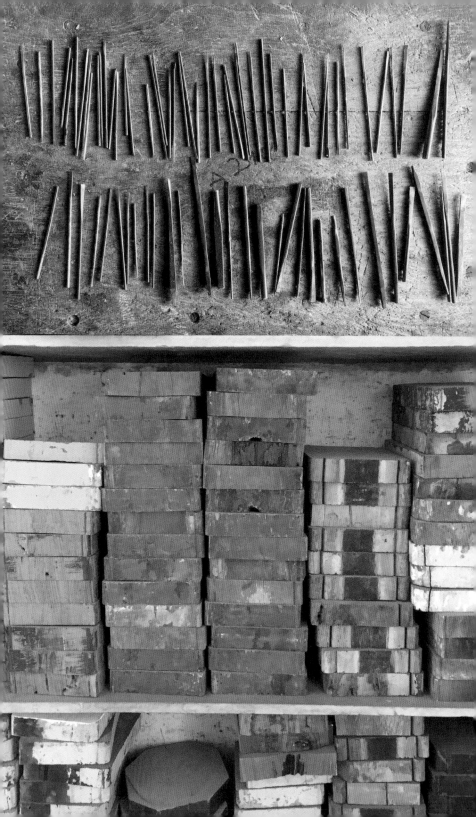

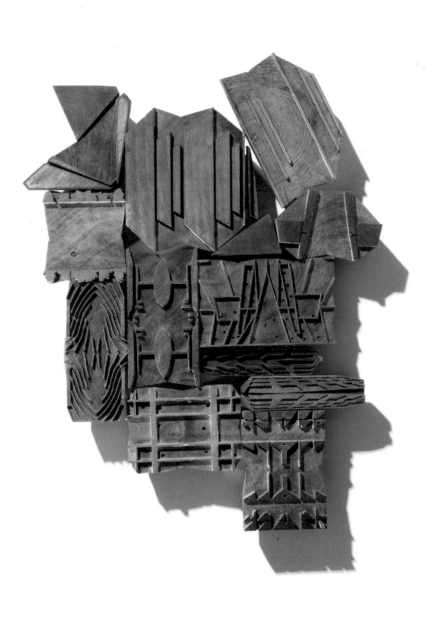

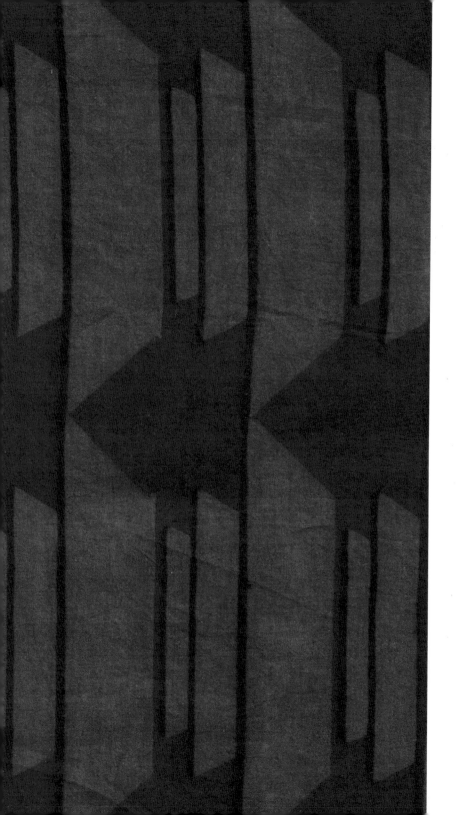

The Memory of Architecture /Antonia Behan

Concepts like "Art," "Craft," and "Design" can feel like colonial buildings dotting a modern cityscape. From their solid structures and elaborated ornament, it is clear that when they were built, they meant something specific and intended to make their power known. Now weathered, they have lost some of their meanings, but even so, they still shape the spaces of our thinking, making, and acting. Some might reinhabit or reshape them or leave them abandoned. Or they might do what Swapnaa Tamhane's *Mobile Palace* does: invent a new space altogether that superimposes various histories—pre-colonial, colonial, post-colonial, contemporary—but tries to work through them to something different.

In nineteenth-century Europe, art and craft were often separated by medium. Painting and sculpture were "fine arts," while ceramics, textiles, and metalwork were "crafts." In colonial spaces, however, the distinction often had to do more with *who* was making than with *what* was being made. As the historian Partha Mitter has pointed out, although British critics held up Indian objects as ideals of applied art, in the colonial mind, an Indian artist could only ever aspire to be a good decorative— but not fine—artist (Mitter 1994: 52). Behind this assumption lay further distinctions: between the mind and the body, the head and the hand, form and matter, design and labour. Colonial racial hierarchies were thus conflated with artistic and technical ones.

Tamhane's intervention challenges these legacies—and with them, the contemporary practice, derived from post-conceptual art, of privileging an artwork's concept while leaving the fabricators of its physical manifestation nameless. The artworks in *Mobile Palace* were made by many artists: Tamhane relied on Mukesh Prajapati, Salemamad Khatri, and the women of Qasab Kutch Craftswomen Producer Co. Ltd., not just for their skills in block carving, block printing, and embroidery, but also for their knowledge of material and process, colour and dye combinations, pattern repeats, and stitching. These works are a conversation through cloth, passing through multiple hands, a process of both thinking and making materialized.

In doing so, they also engage with other histories. After all, textiles are not just art but an industry. Beginning in at least the first millennium, Gujarati block-printed and painted textiles were traded in large quantities across the world. Rather than simply an example of local tradition, Indian textiles were global products. Artisans' knowledge included awareness of their anticipated consumers and the latter's preferences, for which they adapted their motifs and colours: red figural motifs for Javanese buyers or small repeated floral motifs on indigo for Egyptian use. Desire for dyed cottons brought traders, companies, and eventually colonial powers to India.

Collecting Indian knowledge of dyeing and printing helped British companies establish rival factories, and over the course of the colonial period, British industrial goods displaced Indian cloth. They were able to do so partly because of industrial technology, but also due to colonial policies that undercut the sale prices of Indian cloth. It was to resist these new conditions that, in the early 20th century, Gandhi mobilized the history of India's cotton industry as an object lesson in the effects of colonial rule. He exhorted supporters of Indian independence to make their own hand-spun and handwoven cloth (khadi) and to wear the clothing they had made for themselves, partly as a boycott of British cloth, partly as a symbol of unity and self-sufficiency. Ironically, however, the coarse, plain khadi stood in contrast to the work of skilled professionals, and by rejecting colour and decoration, undervalued the skill and knowledge of artisans that had made Indian textiles famous.

In a newly independent India, the Ahmedabad Textile Mill Owners' Association instead sought to recapture India's place in the global textile industry through factory production. In its decision to commission the internationally recognized modern architect Le Corbusier to build them a new headquarters, we can see both the hope and status the association claimed for its enterprise, but also the return and reconfiguration of elite power. Le Corbusier's architecture of visual control, which sought to exclude on-the-ground experience, prompted the political philosopher James C. Scott to call his work in India an exemplification of "seeing like a state" (Scott 1998: 130–132). If Tamhane's *Mobile Palace* is to get away from colonial structures of thought and experience, visual skill will get us only so far.

Cotton pressed rather than woven becomes paper; an embroidery needle acts as a pen. In calling upon these associations, Tamhane's works on khadi paper join a long history. In many languages, words for literary compositions reveal their origins in textiles: a text weaves (Latin: *texere*) together words, just as a *sutra* sews (Sanskrit: सिव्) together aphorisms. Text and textiles share the functions of recording, registering, narrating, and communicating. Yet beyond being used as official records, painted narrative imagery, or communication expressed through colour and pattern, textiles can also reveal a world outside the limits of textual records. To follow the conversation that is embodied in *Mobile Palace* requires different skills, fluency in a different language. From Tamhane's *Translation*, 2017, we might learn to read not just inscriptions and marks but the paper itself, how it was made, and what it was made from. As visitors in the *Mobile Palace*, we cannot be just spectators; instead, we must learn to become readers of materials and techniques.

Mobile Palace's medium is particularly well chosen for this purpose. Block printing is a complex process of layering. Colour is rarely applied directly onto the surface with the blocks; instead, prints are the result of a set of steps that involve adding and removing mordants and resists, dipping the cloth into dye vats of different colours in the right order, drying, bleaching, and repeating. Mordanting prepares the fabric to absorb dye, while resists create areas in which it is prevented from being taken up. The process and sequence must be kept in the printer's mind since the shapes and colours of the final textile are sometimes revealed only at the very end.

Under the peaks of tents and the folds of mechanical rollers, the space we are in recalls the motion of an industrial textile factory, the cloth spinning over rollers and draping between them as it is passed from one process to the next. Alternatively, it might recall the industrial opulence of British exhibitions, where displays of machinery that processed raw materials extracted from the colonies were a form of machine art before machine art. Such exhibitions participated in the modern dream of eliminating the human hand—the cloth, untouched, floating between rollers on machines in a smooth and endless motion. And

yet the interruption of the motifs in *Mobile Palace* breaks the sense of mass production and endless repetition associated with the perfection of roller-printed industrial cloth. The break is not just visual: it also represents the break in the printer's rhythm and usual ways of working. Breaking the pattern takes us into the process.

In *Mobile Palace*, block-printed motifs derived from the forms and surfaces of Le Corbusier's building return the architectural facade to fabric. This could be seen as returning architecture to its origins: the nineteenth-century German art historian Gottfried Semper theorized architecture as deriving from fabric, the mobile architecture of the tent eventually solidifying into stone and brick (Semper [1860] 2004: 247–250). On this model, architecture holds its memory of textile through wrapping and enclosure, as the elementary demarcation of interior and exterior. Reversing this process, *Mobile Palace*, we could say, holds the memories of both architecture and architecture-as-cloth; however, its delicate suggestion of space is one in which access is fluid.

If colonial and post-colonial aesthetics alike emphasized the visual—collecting and categorizing according to visual differences, and emphasizing the head over the hand—Tamhane's decolonial approach to Indian textiles might be seen in its recognizing material, process, and skill, the interrelation of labour and knowledge, mind and hand. Similarly, reconfiguring aesthetic appreciation beyond iconography might require not just visual but material literacy from both visitors and scholars. Cotton has a history of resistance, but for *Mobile Palace*, it is perhaps a soft resistance, something closer to the "resist" of its block-printing process: a careful concealing and revealing of layers of history that seep through like dye.

Detail of resist print before dyeing, from *Tent: A Space for the Ceremony of Close Readings*, 2018.

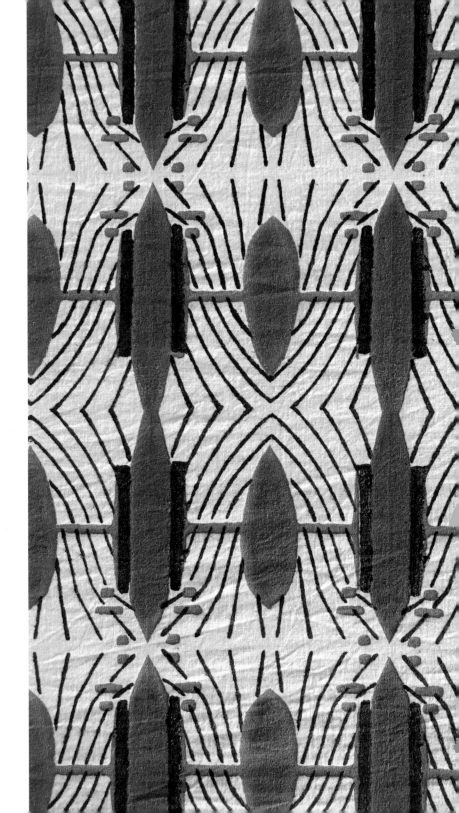

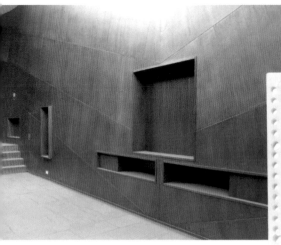

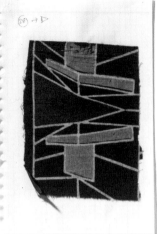

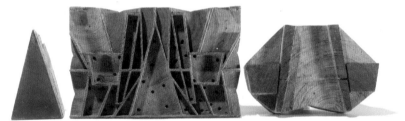

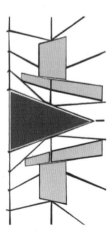

Detail of auditorium, ATMA House, by Le Corbusier, completed 1954, Ahmedabad, Gujarat, India.

Page from Tamhane's notebook, Swapnaa Tamhane with Salemamad Khatri, 2019–2021, paper, cloth. 21 × 15 cm

Wooden printing blocks by Mukesh, Pragnesh, and Avdhesh Prajapati, and Bhavesh Rajnikant, 2019, teak wood. 10.2 × 16.5 × 7.6 cm (largest block)

Swapnaa Tamhane, design based on auditorium in ATMA House, 2019.

pages 21–24: Fabric panels, *Mobile Palace*, 2019–2021, natural dyes, appliqué, and beading on cotton. 115 × 700 cm each

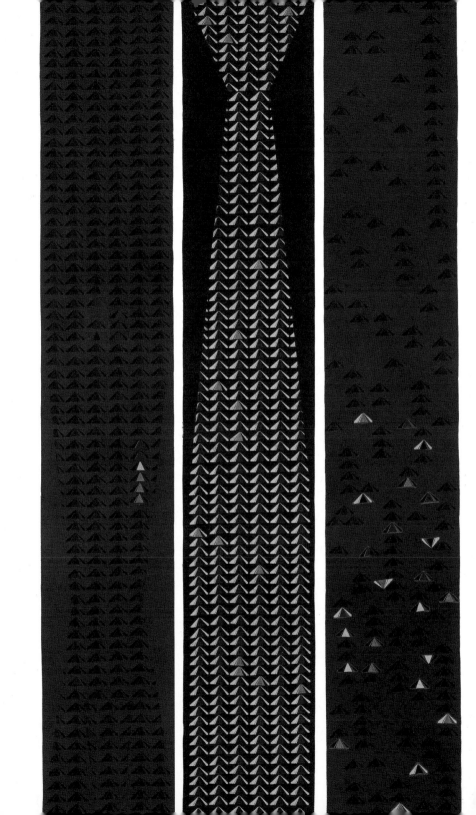

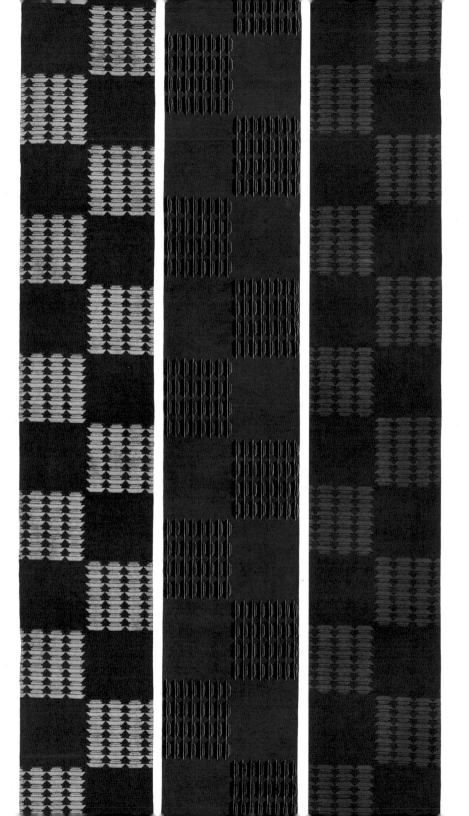

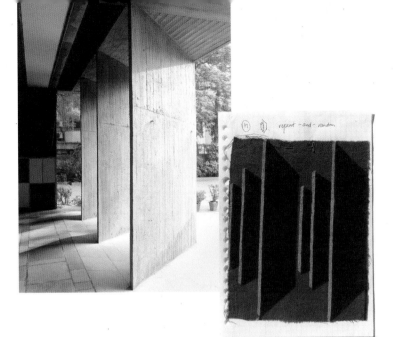

Detail of brise-soleil (sun breakers),
ATMA House by Le Corbusier, completed
1954, Ahmedabad, Gujarat, India.

Page from Tamhane's notebook,
Swapnaa Tamhane with Salemamad
Khatri, 2019–2021, paper, cloth. 21 × 15 cm

Printing blocks by Mukesh, Pragnesh,
and Avdhesh Prajapati, and Bhavesh
Rajnikant, 2019, teak wood.
Approx. 14 × 17 × 7.5 cm each

Swapnaa Tamhane, design based
on brise-soleil in ATMA House, 2019

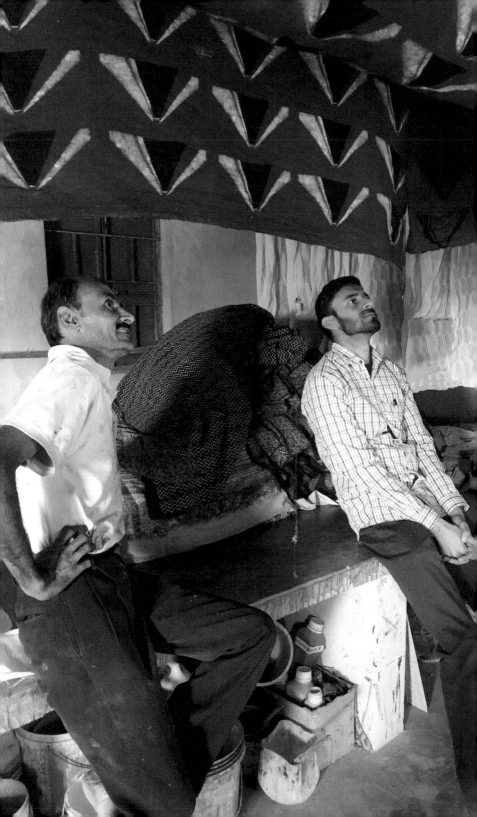

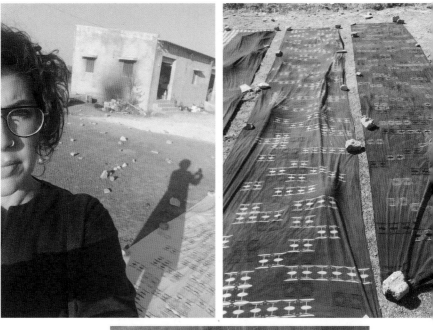

above: Swapnaa Tamhane, selfie, and fabric drying in the sun, 2018, Ajrakhpur, Gujarat, India.

below: Abdulaziz Khatri, Swapnaa Tamhane, Salemamad Khatri at ATMA House, 2020, Ahmedabad, Gujarat, India.

opposite: Salemamad Khatri and Abdulaziz Khatri (Textile Manager, KHAMIR), 2020, Ajrakhpur, Gujarat, India.

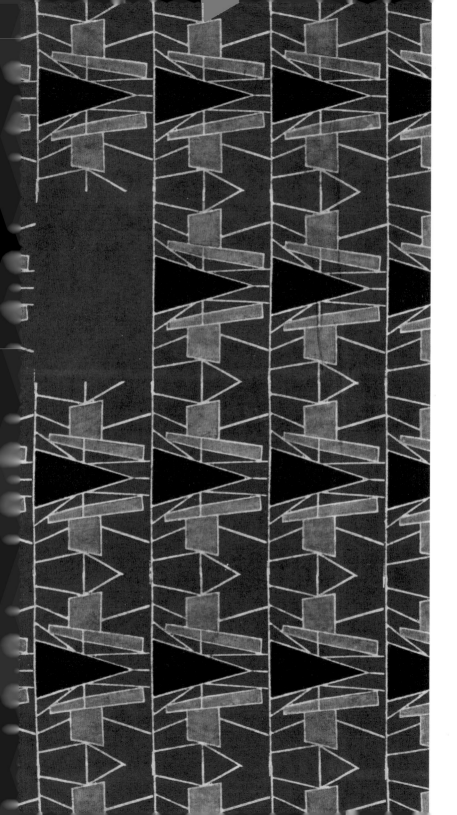

Interruptions /Swapnaa Tamhane

Spaces.

Spaces in-between spaces.

Negative and positive.

But not blank.

Nor empty.

―――

Print. Lift. Step. Print. Lift.

Step. Step.

Print. Lift.

Step.

Print.

―――

Submerge.

Sink.

The cloth is carefully dipped into a dense viscosity of murky blue.

It becomes green.

Then, it oxidizes.

The cloth is carried by each corner and dried directly on the desert sand under the midday sun, weighted down by found rocks.

Rectangular outlines of previously dyed fabrics can be seen extending across a printer's field.

Perimeters within perimeters.

Staggered stones.

———

The wet, thick indigo gleams in the sun.

A hazy, deepish blue reluctantly reveals itself.

It starts to tell us something about its history.

Its rebellion.

Its resistance.

———

Print. Lift. Print. Lift. Print. Print. Lift. Print.

Step. Step. Step.

Print. Lift.

Print.

Step.

The side of the hand hits the top of the wooden block as it meets the cloth.

Callouses form.

The block releases.

The resist stays.

Defiant.

———

Thump ... Thump ... Thump ...

Thump. Thump. Thump.

Multiple rhythms travel across the fields between workshops.

Along with the serenade of love songs played from tinny smartphone speakers.

———

Resist.

Print.

Repeat.

Resist.

———

I ascend a ramp.

It feels ceremonial.

My body is transported from the busy street littered with new cheap architecture into this relic from the future past.

A concrete alien invasion.

That landed along the Sabarmati River in the early 1950s.

In a post-colonial failed utopia, driven by conflicted dreams and demands. And desires for a new nation.

Western experts were invited.

———

The ramp is only for me.

Or so I like to think.

The hot wind rushes past me, beyond me as I ascend.

It moves from the front of the building to the back.

No closed walls.

The wind continues through the building, towards the river.

Light cascades in at a sharp angle, bathing the concrete floor, forming a series of loose isosceles that expand and wash away.

I walk towards where the concrete ends and wood begins.

A doorway.

A large wooden door.

I enter.

A space of veneration opens out and above me.

A cathedral.

Lines in the Burmese teak panelled walls swirl around me.

Round walls—like fabric—pretend to envelop me.

The concrete ceiling swoops down and up again.

It's an auditorium. It's a space for meetings. Industry meetings.
To discuss the ups and downs of their textile mills. An industry that
had been denied to them by the British.

A headquarters. A clubhouse. A private space.

All the furniture has been removed.

I'm not supposed to be here.

This is not for me.

Or for generations of my family—forwards and backwards.

Even today.

This is for the elite.

Like the mobile palaces of the Mughals.

———

A motif.

A motif that is repeated.

A desire for eternal repetition. Broken by broken motifs.

An ornament.

An ornament that was drawn by hand, carved by hand, printed by hand.

Imperfect perfection.

Rekh. Datta.

Line. Filler.

They are separated. An outline without its compatriot, its content, its comrade.

An incomplete motif.

A broken ornament.

A break in the pattern.

———

Print. Print. Lift. Lift. Step. Print.

Lift.

Step.

Print.

Swapnaa Tamhane, *Untitled (Nazar)*, 2017, water-soluble graphite on handmade khadi paper. 29 × 23 cm

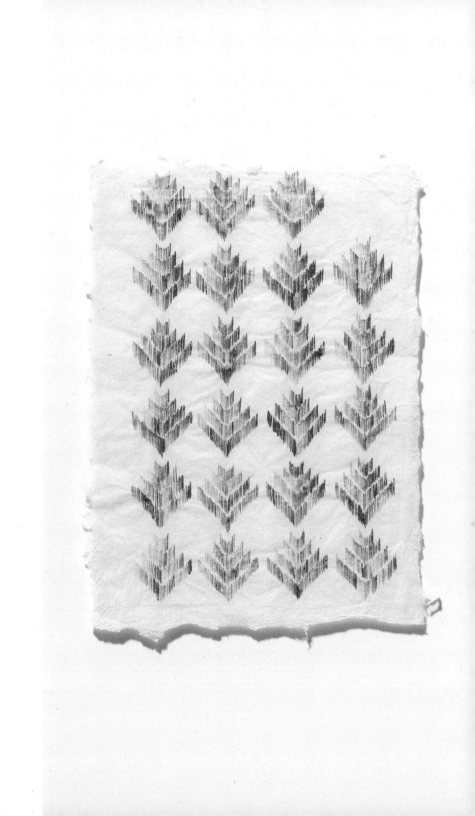

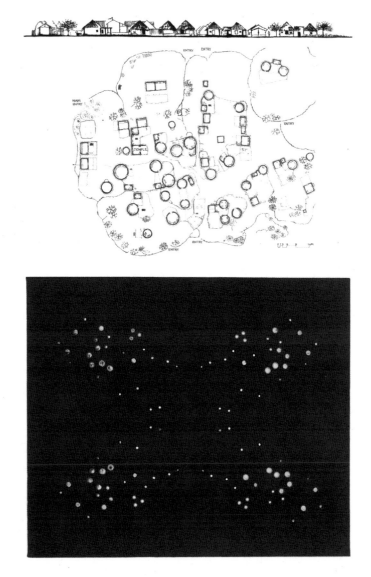

above: Plan of Ludiya village, Kutch,
Gujarat, India. Courtesy Ar. Yatin Pandya
(drawn after Kulbhushan Jain).

below and opposite: Swapnaa Tamhane,
with Qasab Kutch Craftswomen Producer
Co. Ltd., *Bird's-Eye 2*, 2020, natural dyes,
embroidery, and mirrors on cotton.
96 × 113 cm

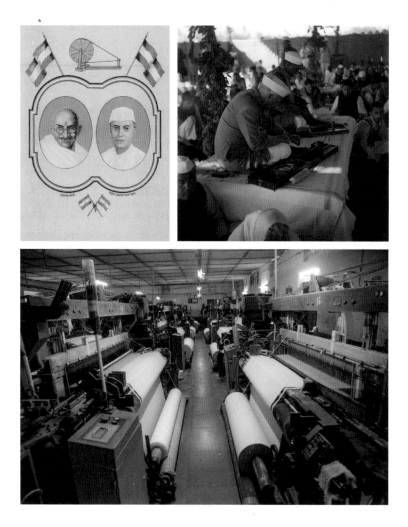

Anant Shivaji Desai? of Ravi Varma Press, Poster of Mahatma Gandhi and Pandit Jawaharlal Nehru with spinning wheel and flag of India, c. 1950, lithograph. 25.5 × 35.8 cm, ROM 2004.60.28.

Mazher S. Master, ARPS (1920–1977), Prime Minister of India Jawaharlal Nehru and President Rajendra Prasad using box charkhas (foldable spinning wheels) at a political gathering, 4 February 1953, digital scan from medium format negative, Delhi, India. Reproduced with the permission of his son, Mustafa Master.

Machine loom in a textile factory, January 2021, Burhanpur, Madhya Pradesh, India.

opposite: Wooden printing blocks in Salemamad Khatri's studio, 2020, Ajrakhpur, Gujarat, India.

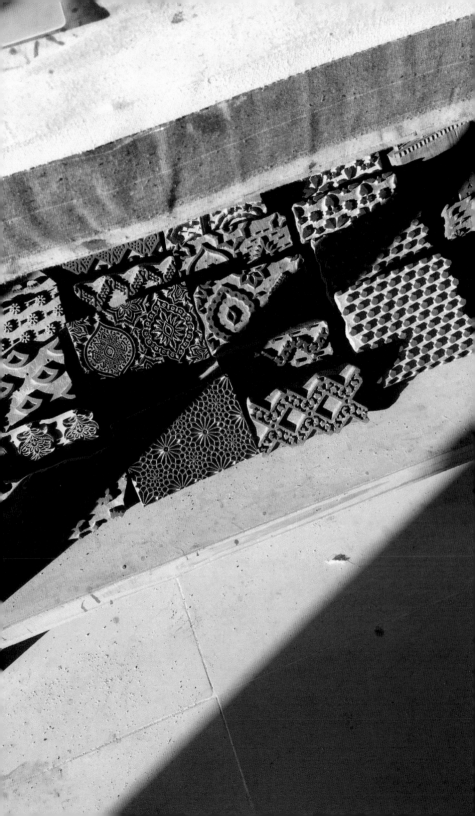

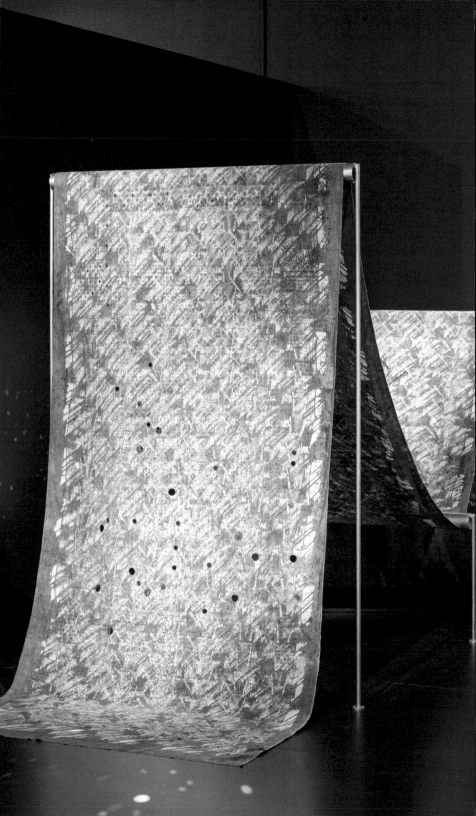

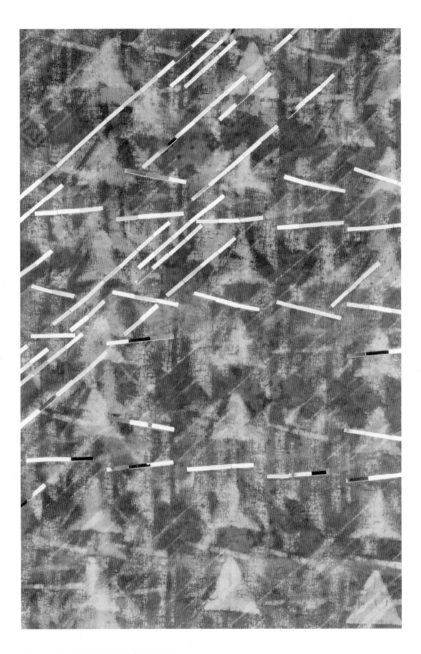

Swapnaa Tamhane, with Salemamad Khatri,
Achadiya 1, 2020–2021, indigo, embroidery,
and mirrors on cotton, aluminum pipes,
and steel stands. 125 × 825 cm (cloth),
213 × 152.5 × 297 cm (installation)

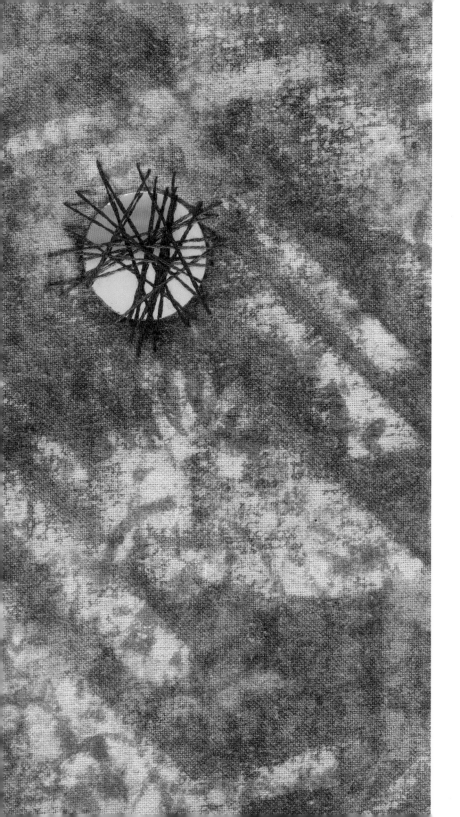

Decentring Design /Amanda Pinatih

February 2016—Mumbai

The bustling streets of Dharavi provide little refuge from the sweltering climate. While not immediately apparent from the outside, Dharavi is a homegrown creative ecosystem in the middle of Mumbai. Potters, embroiderers, weavers, screen printers, metalsmiths, and leather workers have come from all over India to gather in the micro-universe of Dharavi. It is this artisanal energy that provides an environment to research what design can do for crafts and vice versa. I have come to set up a mobile design museum, the first of its kind in Dharavi to showcase local talent through a nomadic exhibition space. It employs design as a tool to promote social change and innovation on a global scale and challenge the boundaries of what a museum can be. Through collaboration with various artists, makers, and mediators, I came to realize that it is in Dharavi where we can learn approaches to rethink the western design canon.

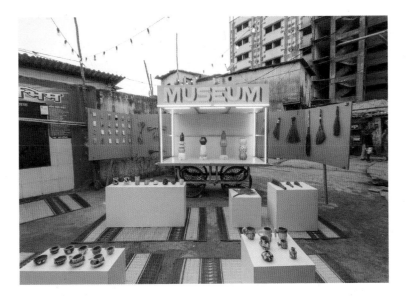

Design Museum Dharavi, co-founded by Jorge Mañes
Rubio and Amanda Pinatih, with creative coordinator
Kruti Saraiya, Mumbai, India, 2016.

opposite: Detail of *Achadiya 1*, 2020–2021.

45

Designing Crafts

Knowledge of handmade trades is embedded in India's culture with millions of people having an artisanal practice in the country today. Since the Age of Enlightenment and the Industrial Revolution in the 18th century, where scientific advancement was celebrated, new technology, mass production, and the machine made have been threatening to push away the handmade in many countries around the globe.

This is where design comes in. Design is important for India; it is a tool for change, a system to go beyond being a manufacturing force for the West, and an instrument to make local techniques conform to contemporary aesthetics.

As a formal industry, design is a relatively new establishment in India. The National Institute of Design was the first design institution in the country. Mostly based on Bauhaus principles, it combined a design school and research centre and recognized the concept of design as an instrument of socialism. Established in 1961, after recommendations in Charles and Ray Eames's *The India Report* (1958), the school was a practical answer for a newly independent India faced with the immense mission to build a nation. From the school's very foundation, documenting craft techniques, knowledge of which was understood to be passed on through a system of familial apprenticeship in a non-systematic way, and researching local materials were considered important, mainly to create an identity for Indian design. At the time, crafts were considered "authentic," timeless skills and aesthetics in opposition to mass-produced objects or fine art. Crafts were not understood as innovative or progressive, a concept tightly tied to colonial agendas.

Yet how can designers today draw on this historical knowledge to forge a distinct design identity, and how can design act as a force for positive change?

Collaborating Disciplines

There is an inextricable link between the artisanal and design where boundaries between the two disciplines overlap and blur due to their inherent materiality. But unlike designers, craftspeople in India have

historically followed the trade practiced by their family and community. Consequently, the innate design culture in India is quite anonymous. The architects and craft professionals that were the masterminds behind buildings such as the Lal Qila (Red Fort) in Old Delhi or the Kailasanatha Temple in Kanchipuram are seldom known (McGuirk 2012). Similarly, the craftspeople in Dharavi that produce goods sold in Mumbai and around the globe have not been recognized as individual makers, let alone as designers.

Although it is one of anonymity, the artisanal sector is India's second largest employment sector and, as we learnt in Dharavi, focused on commercialization, creativity, and knowledge exchange. To open doors for a new design movement and a clear design identity, design should recognize the presence of this expertise (Jadhav & Jain 2021). Handmade techniques reflect culture and history; therefore, they make design meaningful, and they give the industry roots and a connection to past, present, and a possible future. However, a meaningful relationship is achieved only through collaboration between artisans and designers on an equal footing. Local skills are adapted to contemporary design, and designers can bridge the gap between market and maker (Kapur & Mittar 2014: 3), with designers finding original and creative ways to make their own work relevant. This collaborative innovation between designer and artisan is a means of expanding the craft vocabulary, where the combination of techniques and design is able to identify with the local as well as with the global. When craft is approached through design, and as design, craftspeople are seen as individual makers and local aesthetics as a design strategy.

Mobile Palace

It is precisely from this design perspective that we can understand the work of Swapnaa Tamhane. Tamhane imbeds herself in historical textile techniques and the landscape where they originated, connecting with the natural world and a handmade history. It is here where a symbiosis comes alive, where she marries concepts of both the handmade and design. The artworks in *Swapnaa Tamhane: Mobile Palace* challenge the view on the relation between designer/artist and craftsperson, in which artist decides and artisan makes, and contest our understanding of colonial legacies. We can recognize this in how Tamhane works

with wood block carver Mukesh Prajapati and textile dyer and printer Salemamad Khatri on an artistic level, making space for their agency; how she disrupts the normally repetitive block-printed patterns; and how she adds mirrors, an often-used decorative element in Kutch textiles, not embroidering the edges of the mirrors but drawing threads across them. Carrying such deep cultural signifiers as well as contemporary translations of the local techniques and symbols, Tamhane's textiles can be celebrated as bearers of social relationships (Botha 2016: 39).

Like the Design Museum Dharavi, Tamhane makes space for the agency of makers in working together in the design process as peers and giving credit to them, resulting in contemporary works that honour local techniques, materials, and history. Both the Design Museum Dharavi and *Mobile Palace* can then be understood as sites where the colonial legacy of anonymity is challenged through design, and where historical knowledge is not something static but a continuing, dynamic source of inspiration.

Salemamad Khatri in his workshop, 2020, Ajrakhpur, Gujarat, India.

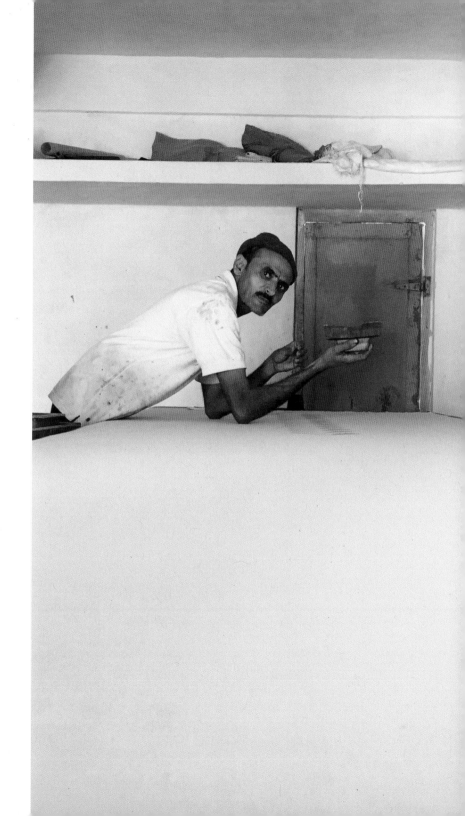

Swapnaa Tamhane, *Study 1*, 2018, wood
block print on khadi rag paper. Printed at
Glasgow Print Studio. 29.5 × 22.5 cm

opposite: Swapnaa Tamhane, *Untitled
(Phulkari)*, 2017, water-soluble graphite
on handmade khadi paper mounted on
cotton. 68.5 × 45.5 cm

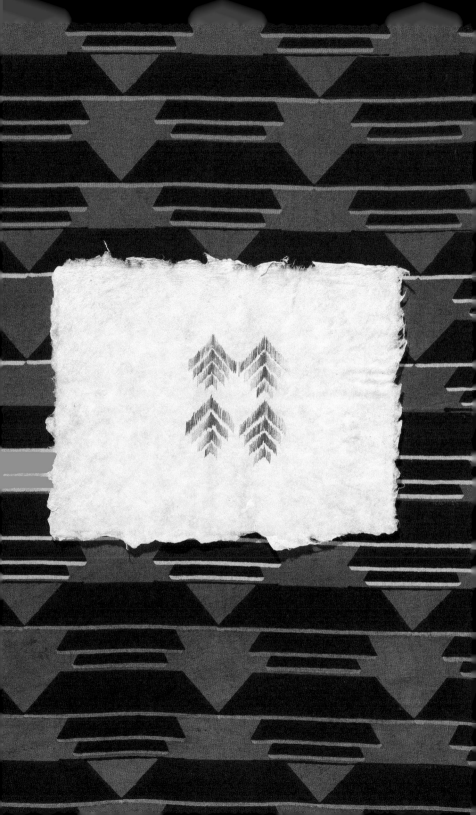

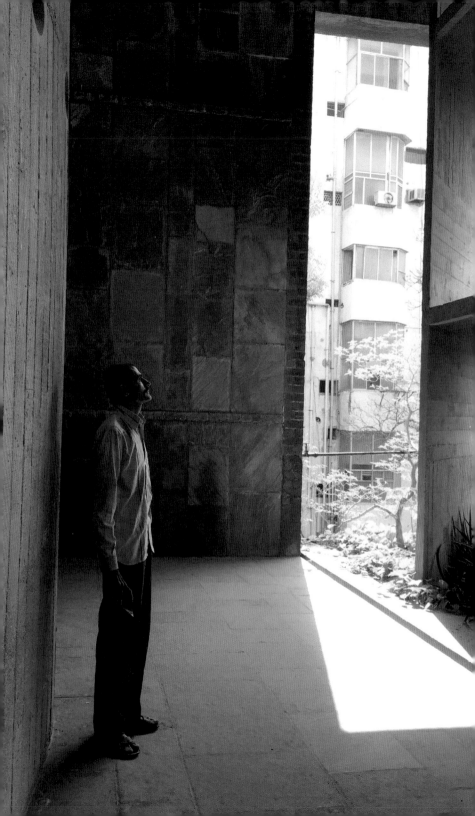

Salemamad Khatri dyeing fabric in indigo
bath and (opposite) at ATMA House, 2020,
Ajrakhpur, Gujarat, India.

Works Cited

Balaram, Singanapalli. "Bauhaus and the Origin of Design Education in India." *bauhaus imaginista journal* (22 January 2019). bauhaus-imaginista.org/articles/3268/bauhaus-and-the-origin-of-design-education-in-india

Botha, N. "Design: Undoing the Single Story" in *Design Museum Dharavi Book*. Ed. J. Mañes Rubio and M.N.A. Pinatih. Amsterdam: The Future Publishing & Printing, 2016: 38–39.

Jadhav, Ketaki and Rishav Jain. "The Future of Design: Craft an Emerging Movement." *Descriptio*, Vol. 3, No. 1 (2021). journalsacfa.apeejay.edu/index.php/descriptio/issue/view/1

Kapur, Harita and Suruchi Mittar. "Design Intervention & Craft Revival." *International Journal of Scientific and Research Publications*, Vol. 4, Issue 10 (October 2014): 1–5. ijsrp.org/research-paper-1014/ijsrp-p34119.pdf

McGuirk, J. "How Will India Design Its New Identity?" *The Guardian* (15 March 2012). theguardian.com/artanddesign/2012/mar/15/india-design-identity-forum-new-delhi

Mitter, Partha. *Art and Nationalism*. Cambridge: Cambridge University Press, 1994.

Scott, James C. *Seeing Like a State: How Certain Schemes to Improve the Human Condition Have Failed*. New Haven: Yale University Press, 1998.

Semper, Gottfried. *Style in the Technical and Tectonic Arts; or, Practical Aesthetics*. Trans. Harry F. Mallgrave. Los Angeles: Getty Research Institute, 2004. Originally published in German, 1860.

Artists

All the artists in the exhibition *Swapnaa Tamhane: Mobile Palace* contibuted their skill and agency in producing the works on display. Historically, colonial legacies devalued and separated craft from art, but here, each collaborator is recognized.

For the title artwork, *Mobile Palace*, Tamhane conceptualized the project, selected the motifs, and translated them into flat designs, as well as applied beading, embroidery, and appliqué to the finish panels. Prajapati, with his sons and nephew, carved Tamhane's designs into wood. Khatri used the blocks to create repeat prints on the panels according to Tamhane's sketches and his own choices. The Qasab Kutch Craftswomen Producer Co. Ltd. embroidered circular mirrorwork.

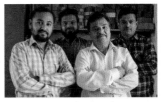

Swapnaa Tamhane (b. 1976) is an artist and curator based in Montreal, Quebec, Canada, who works across media to destabilize colonial constructs and explore what it means to make a mark.

Mukesh Prajapati (b. 1962), his sons Avdhesh Prajapati (b. 1987) and Pragnesh Prajapati (b. 1991), and his nephew Bhavesh Rajnikant (b. 1987) are artists based in Pethapur near Ahmedabad in Gujarat, India, who carve textile printing blocks from wood.

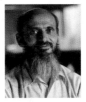

Salemamad Khatri (b. 1981) is an artist based in Ajrakhpur in the region of Kutch in Gujarat, India, who is a block printer and dyer of textiles, working with the NGO KHAMIR, based in Kutch.

Qasab Kutch Craftswomen Producer Co. Ltd. (founded 1997) is a collective of women artists based in the region of Kutch in Gujarat, India, who specialize in embroidery techniques.

Published by ROM with the generous support of the
Louise Hawley Stone Charitable Trust.

© 2022 Royal Ontario Museum
All rights reserved. No part of this publication may be
reproduced, stored in a retrieval system or database,
or transmitted, in any form or by any means, without the
prior written permission of the publisher, or in the case
of photocopying or other reprographic copying, a license
from Access Copyright, The Canadian Copyright Licensing
Agency, Toronto, Ontario, Canada.

Library and Archives Canada Cataloguing in Publication
Title: Swapnaa Tamhane: Mobile Palace; Resist. Print. Repeat.
Edited by Deepali Dewan. Names: Dewan, Deepali, editor.
Container of (work): Tamhane, Swapnaa, 1976– Works.
Selections. Royal Ontario Museum, publisher, host institution.
Description: Catalogue of an exhibition held at the Royal
Ontario Museum from March 12, 2022 to August 1, 2022.
Includes bibliographical references. Identifiers: Canadiana
20220186383. ISBN 9780888545312 (softcover) Subjects:
LCSH: Tamhane, Swapnaa, 1976– Exhibitions. LCSH: Textile
fabrics in art—Exhibitions. LCSH: Installations (Art)—21st
century—Exhibitions. LCGFT: Exhibition catalogs.
Classification: LCC N6549.T3194 A4 2022. DDC 709.2—dc23
ISBN 978-0-88854-531-2

Swapnaa Tamhane: Mobile Palace
March 12, 2022, to August 1, 2022
ROM, Level 3
Curated by: Deepali Dewan

Manager, Publishing: Sheeza Sarfraz
Senior Designer: Tara Winterhalt
Copy Editor: Marnie Lamb

Photo credits: All images courtesy Swapnaa Tamhane unless
otherwise indicated. **Rameshwar Bhatt:** viii, 1, 11 (top, bottom
left), 55 (top right, bottom left); **Brian Boyle/ROM:** 40 (top left);
Brandon Brookbank: 43, 55 (top left); **Philippe Calia and
Sunil Thakkar:** 12–13; **Paul Eekhoff/ROM:** i, ii, iv, viii–ix, 4, 9, 12,
15–16, 22 (top right, middle), 23–26, 27 (top right, middle), 30,
37, 38, 39 (bottom), 42–44, 50–51, 56; **Mahendra N. Parikh/
Shutterstock:** 40 (bottom); **Swapnaa Tamhane:** 10 (bottom),
11 (bottom right), 14, 21, 22 (top left, bottom), 27 (bottom), 28–29,
41, 49, 52, 53; **Vitor Pavao/ROM:** 40 (top right); **Amanda
Pinatih:** 45; **Punit Soni/Qasab Kutch Craftswomen Producer
Co. Ltd.:** 55 (bottom right); **Nathan Willock-VIEW/Alamy Stock
Photo:** 27 (top).

ROM is an agency of the Government of Ontario.

Printed and bound in Canada.